COLOR YOUR WAY THROUGH THE ROCKET CITY

series one:

Exploration and Star Stuff

This coloring book was designed for people of many coloring preferences in mind. It offers pictures that encourage meditative benefits while focusing on coloring small, creative spaces. It has options for people to relax while coloring large dynamic shapes. There are also pages with open spaces for those who enjoy drawing. The unique charm of the ever growing Rocket City is expressed in this series of Coloring Books.

This segment invites you to interact with The Rocket City Space exploration and STAR STUFF.

May you enjoy your life while you color your way through

The Rocket City.

May the following pages be seeds that grow you interest of star stuff.

The images you are about to see are photos of STAR STUFF.

#	TOPIC OF IMAGES	PAGES
1	SATURN V and SATURN the planet	4 -7
2	Robot and Rocket City Challenge	8 - 9
3	Space suits in The Space and Rocket Center	10 - 11
4	Mars . images, the tv show COSMO, NASA sites and Space and Rocket Center	12 - 17
5	Space and Rocket Center sign	18
6	Rockets at Space and Rocket Center	19
7	The Challenger	20 -21
8	Hubble Space Craft is included because it has helped space exploration and it is beautiful	22 -23
9	Earth and the moon Man on the Moon	24 - 25
10	Space Camp sign	26
11	Huntsville Sign taken from the Huntsville International Airport	27
12	The Rocket City Star Trek sign	28
13	"Eggbeater Jesus" First Baptist Church on Governors Drive Huntsville Alabama	29

4

SATURN V at the US Space and Rocket Center

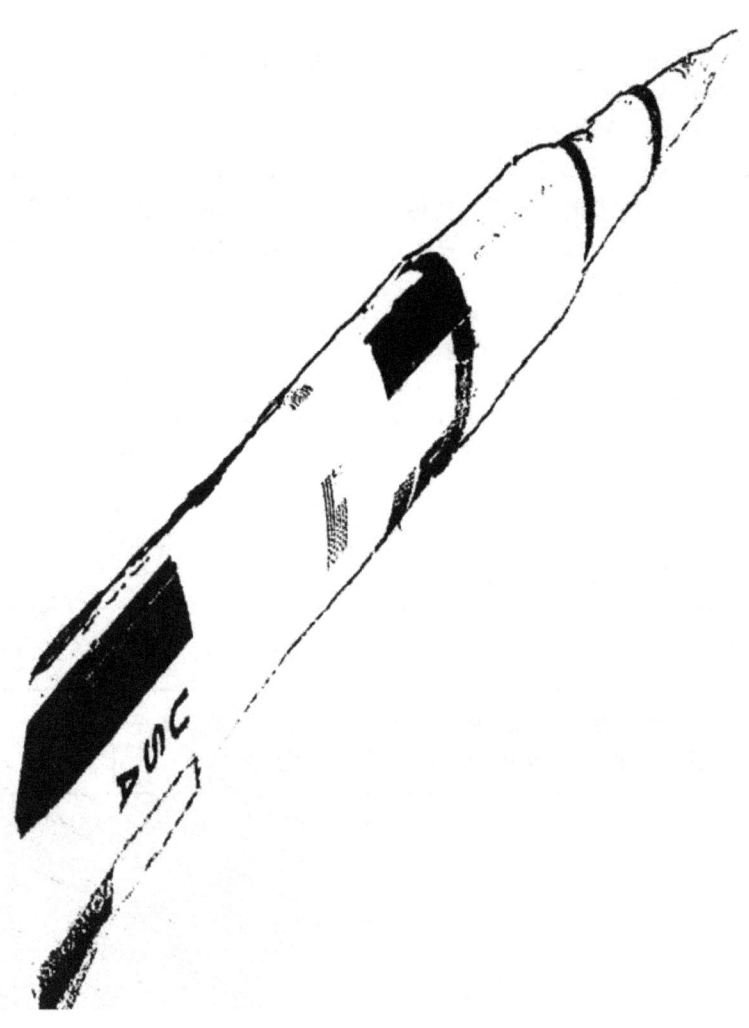

Image of the planet Saturn

SATURN and SATURN V (FRONT COVER UNCOLORED)

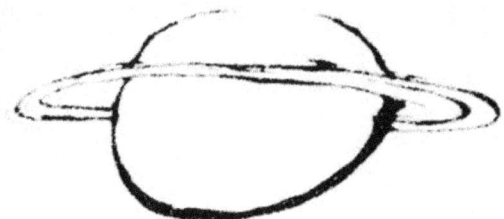

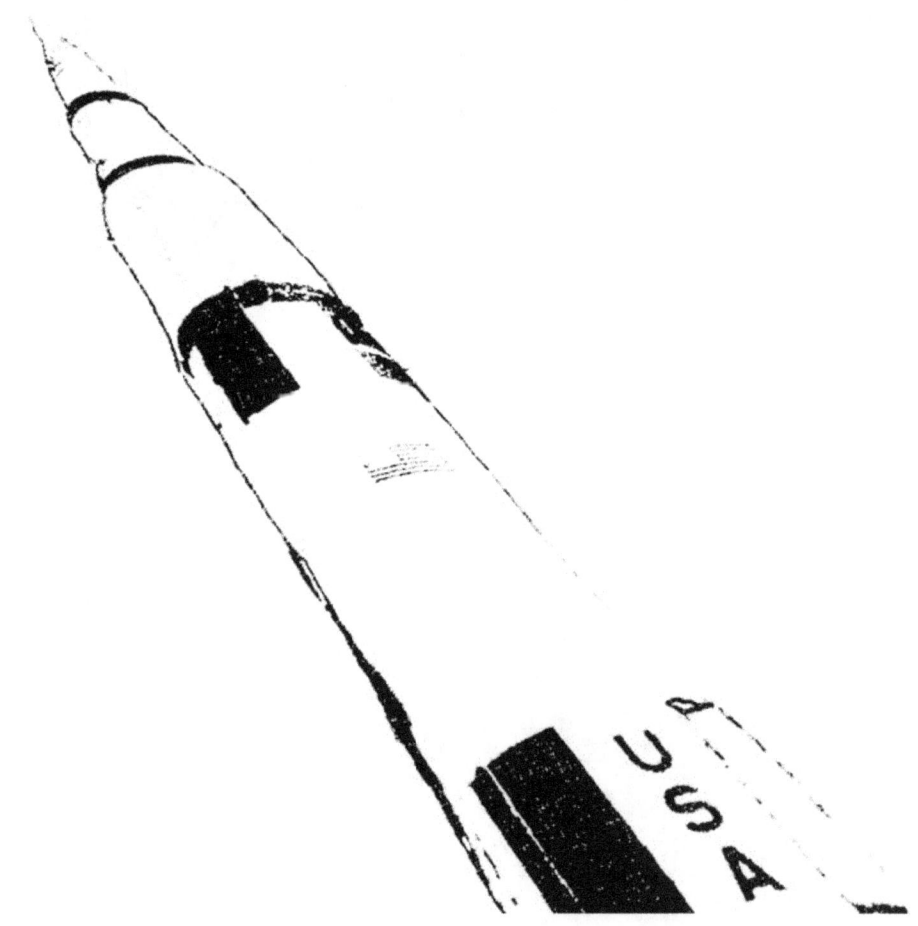

SATURN V seen from a different view

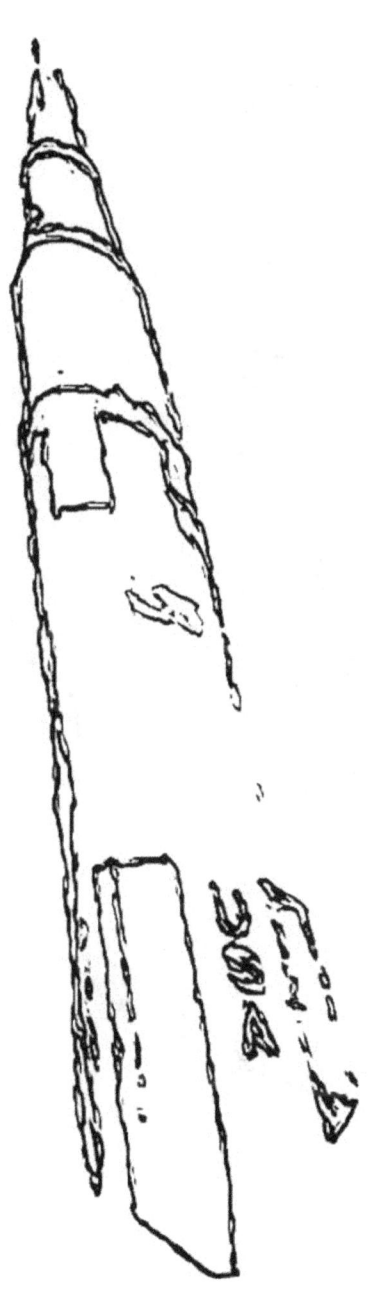

Image taken from the www.nasa.gov. 2016 Robotic Challenge.

Find our more information at www.nasa.gov

Space Suit from the US Space and Rocket Center

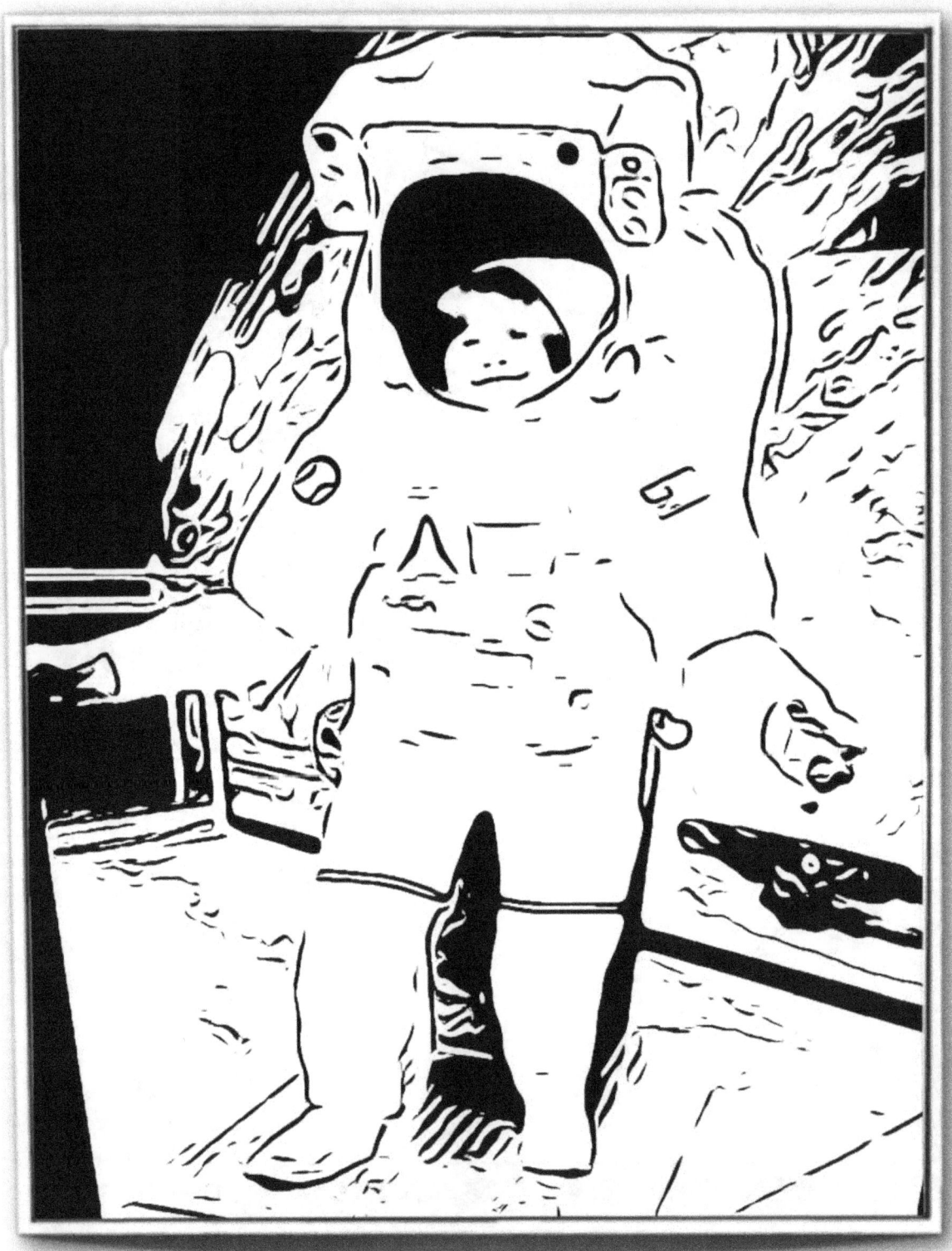

11
Color yourself in the Space Suit from the US Space and Rocket Center

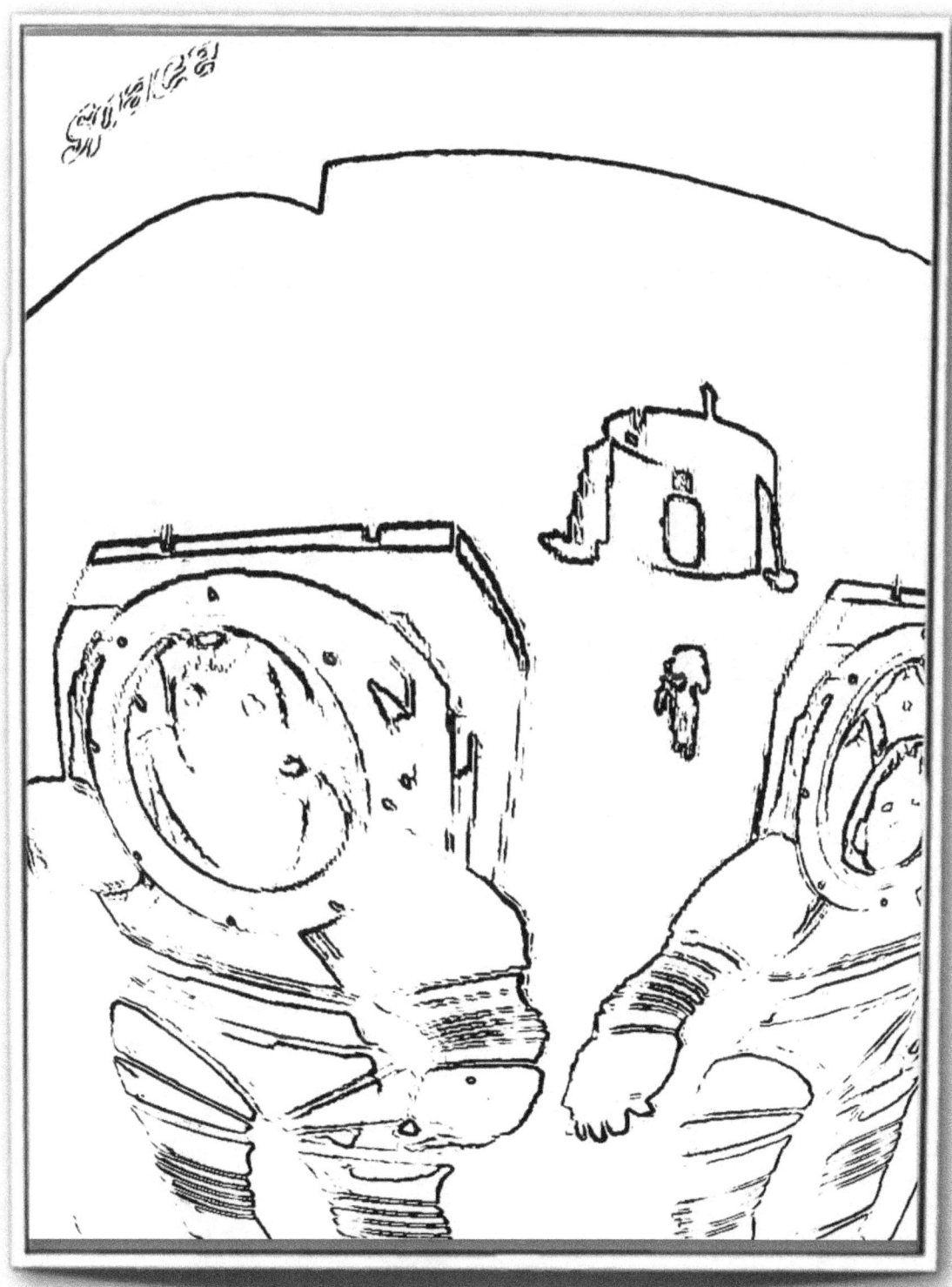

What does Mars mean to The Rocket City?

NASA's Marshall Space Flight Center Huntsville, Al

is helping to launch the first humans to Mars.

To learn more visit www.Nasa.gov.

Earth is the big planet.
Mars is the small one...How would you color them? .

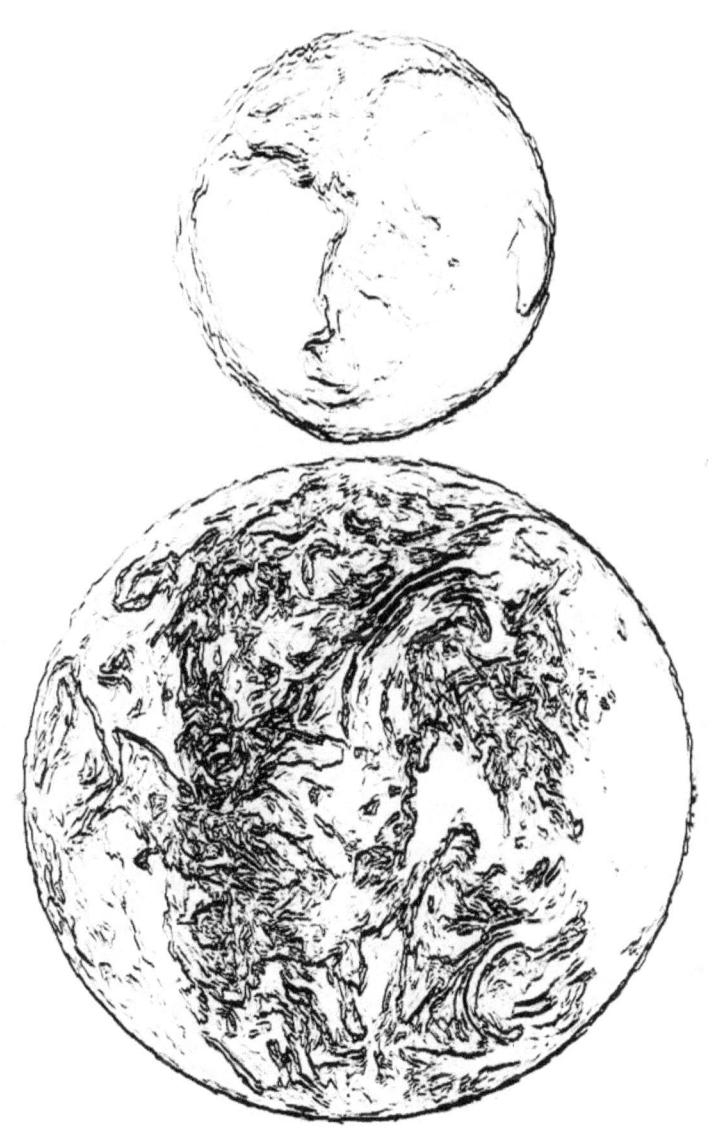

Mars (The Red Planet)

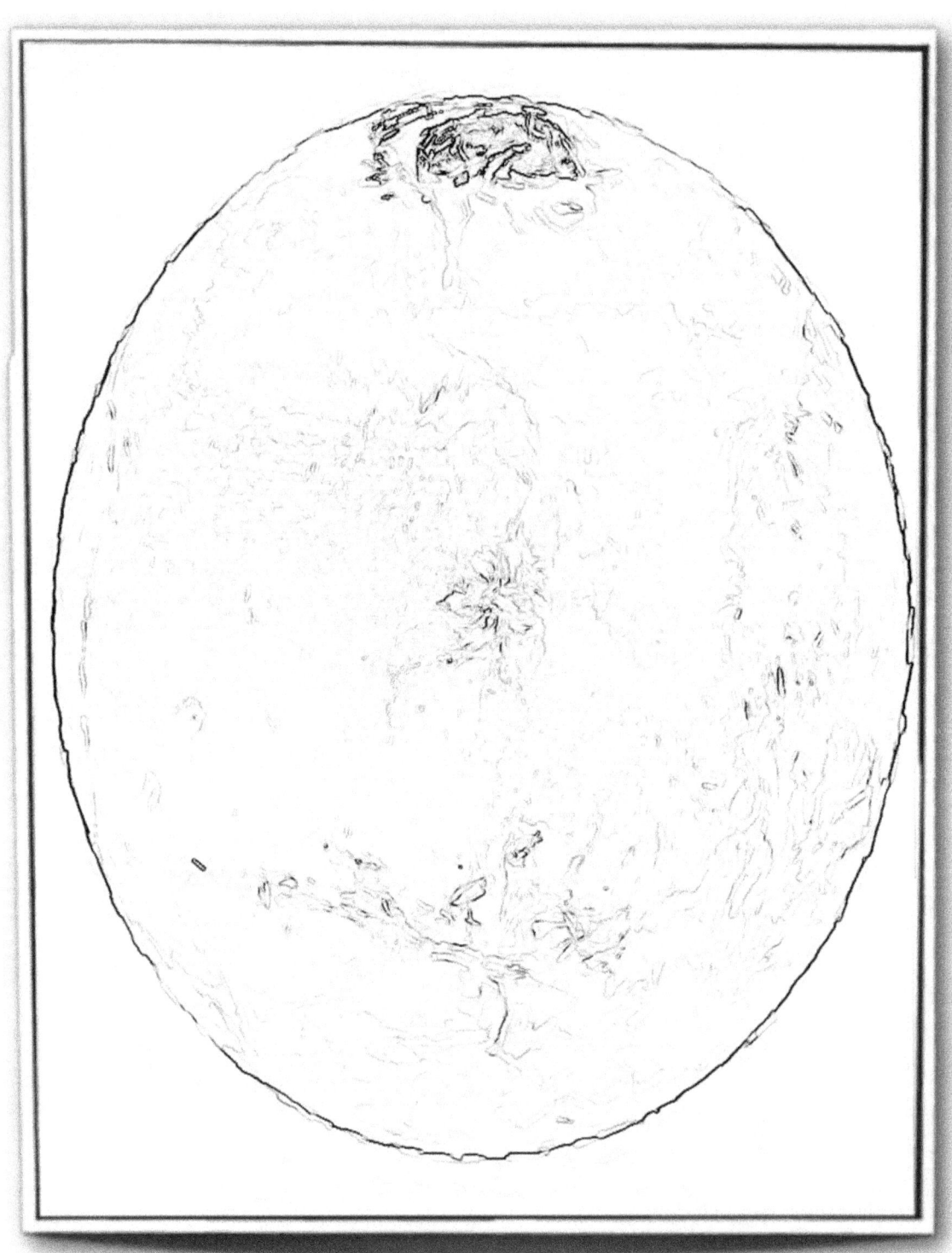

NASA'S Space Craft going to Mars

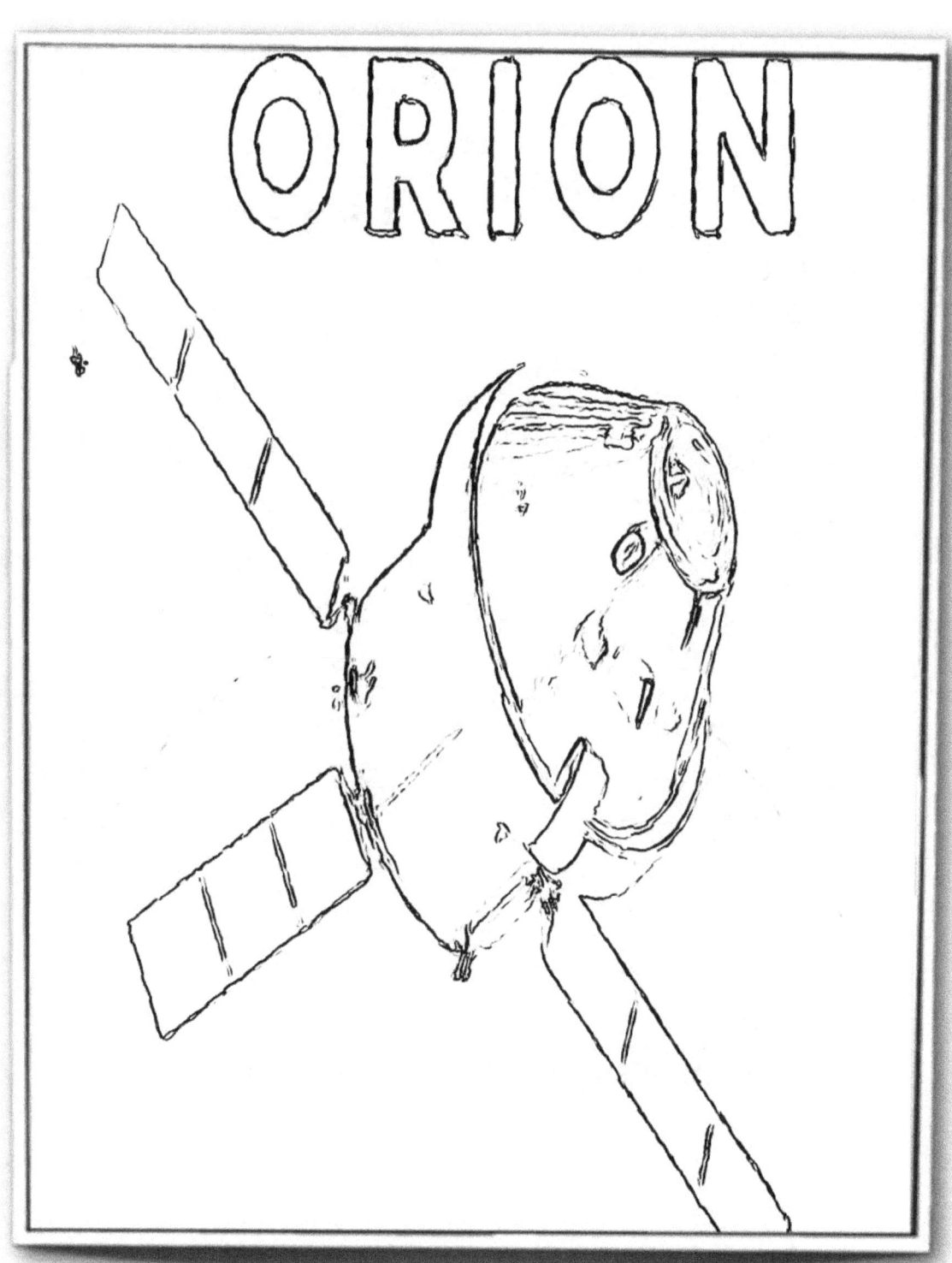

Mars' North Polar Ice Caps

Mars' South Polar Ice Caps

This is the US Space and Rocket Center sign, and this is your coloring book so COLOR IT THE WAY YOU WANT!.

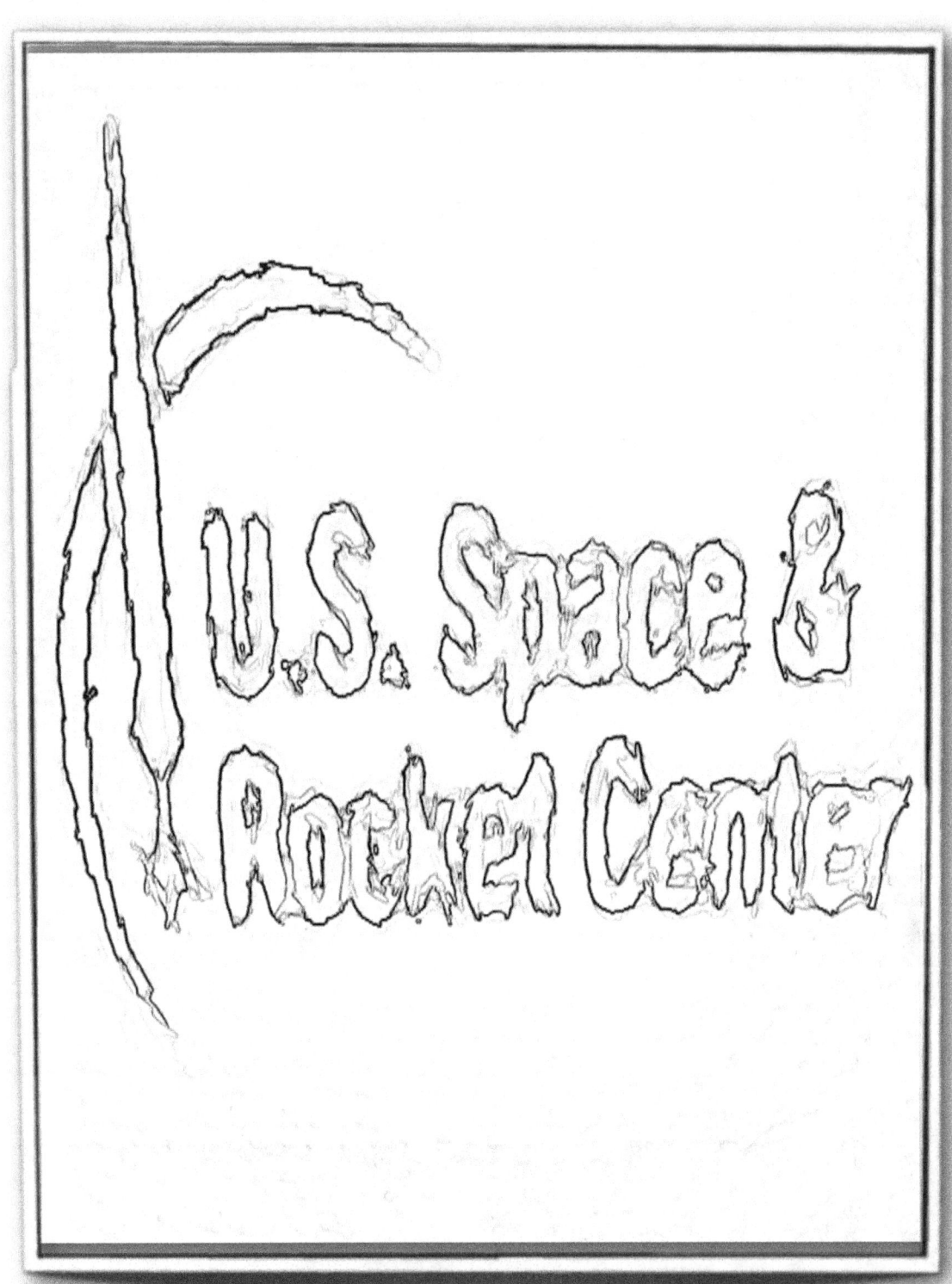

Rockets from the US Space and Rocket Center.

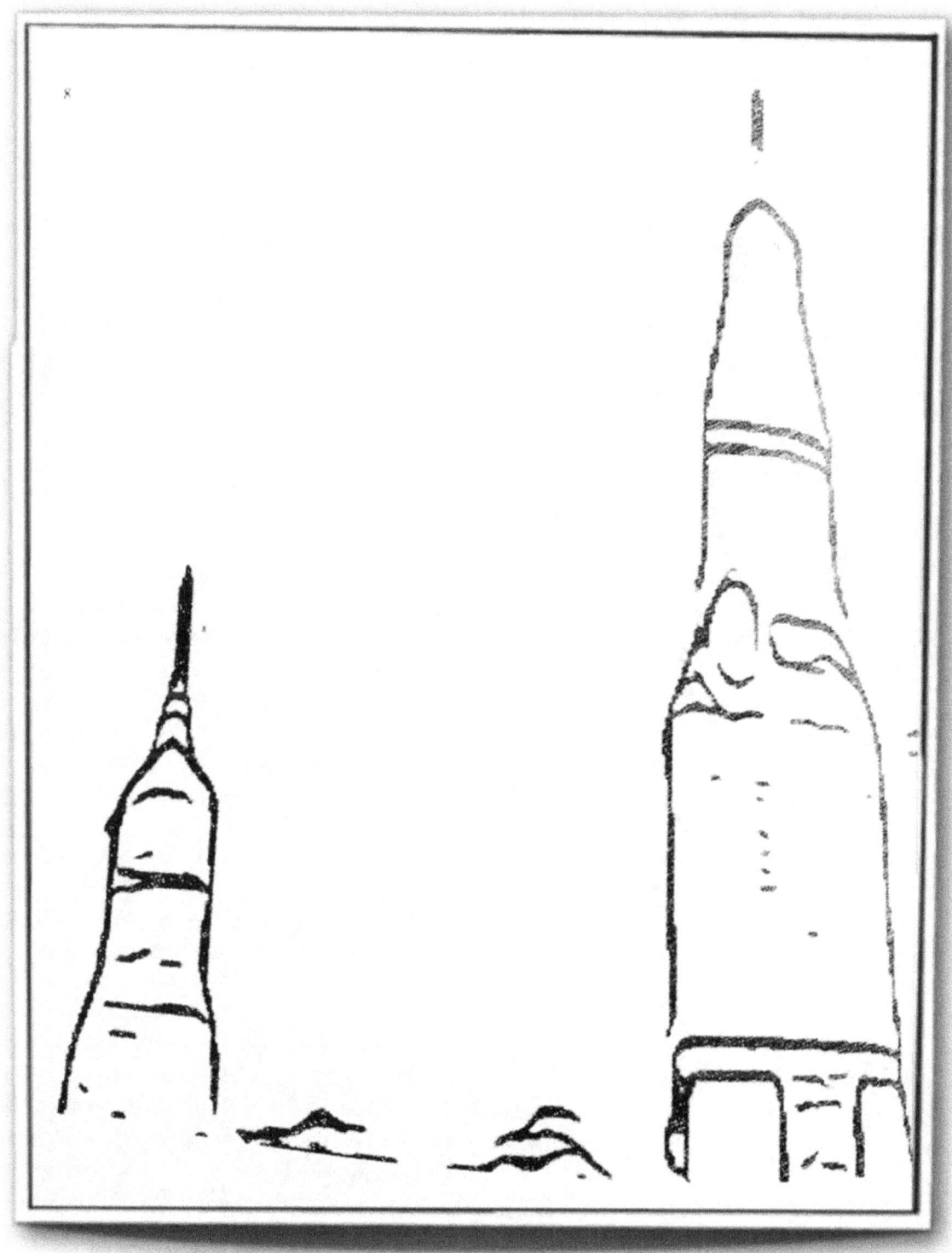

The CHALLENGER Space Ship and the rocket it rides on at The US Space and Rocket Center.

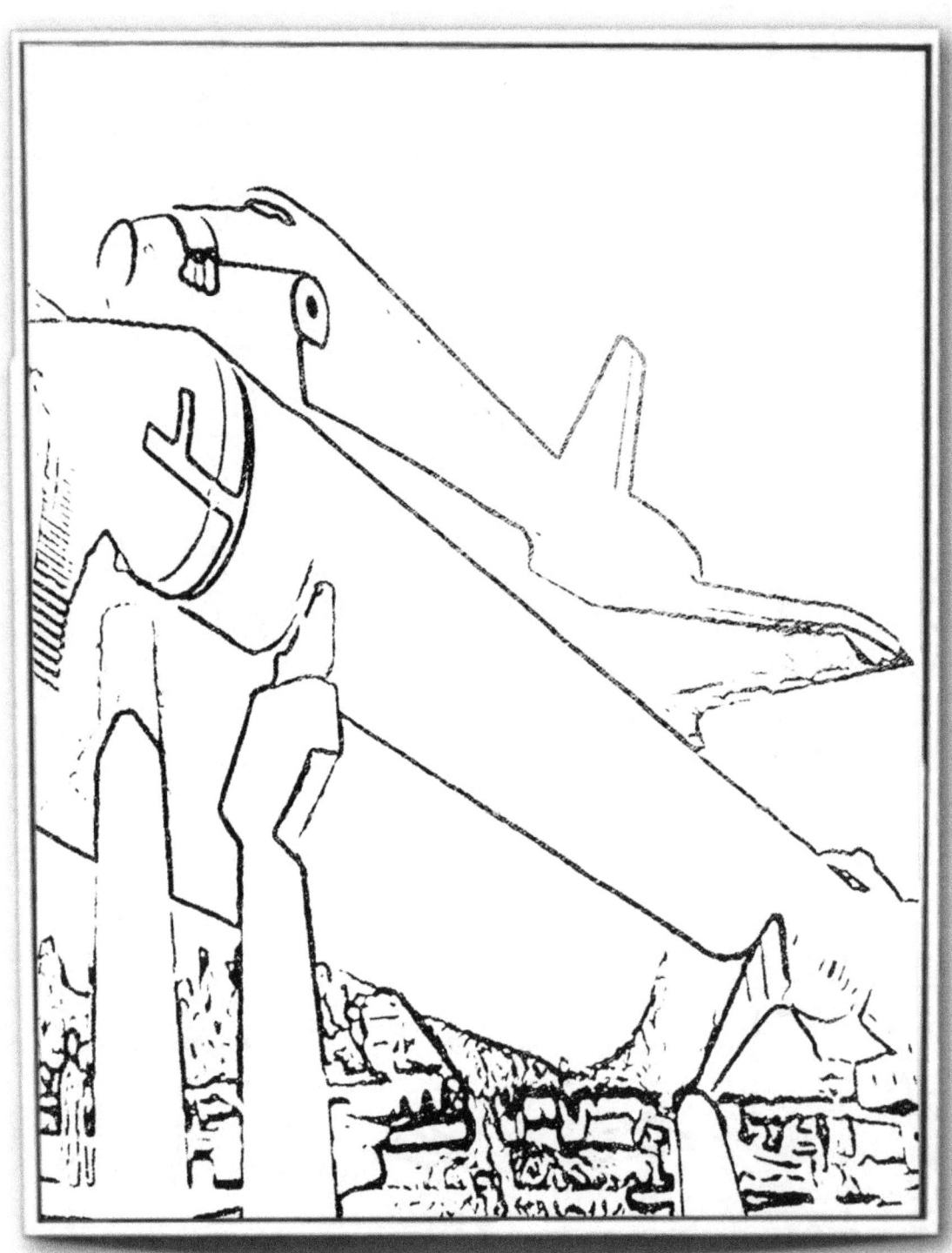

The Challenger from an artist view.

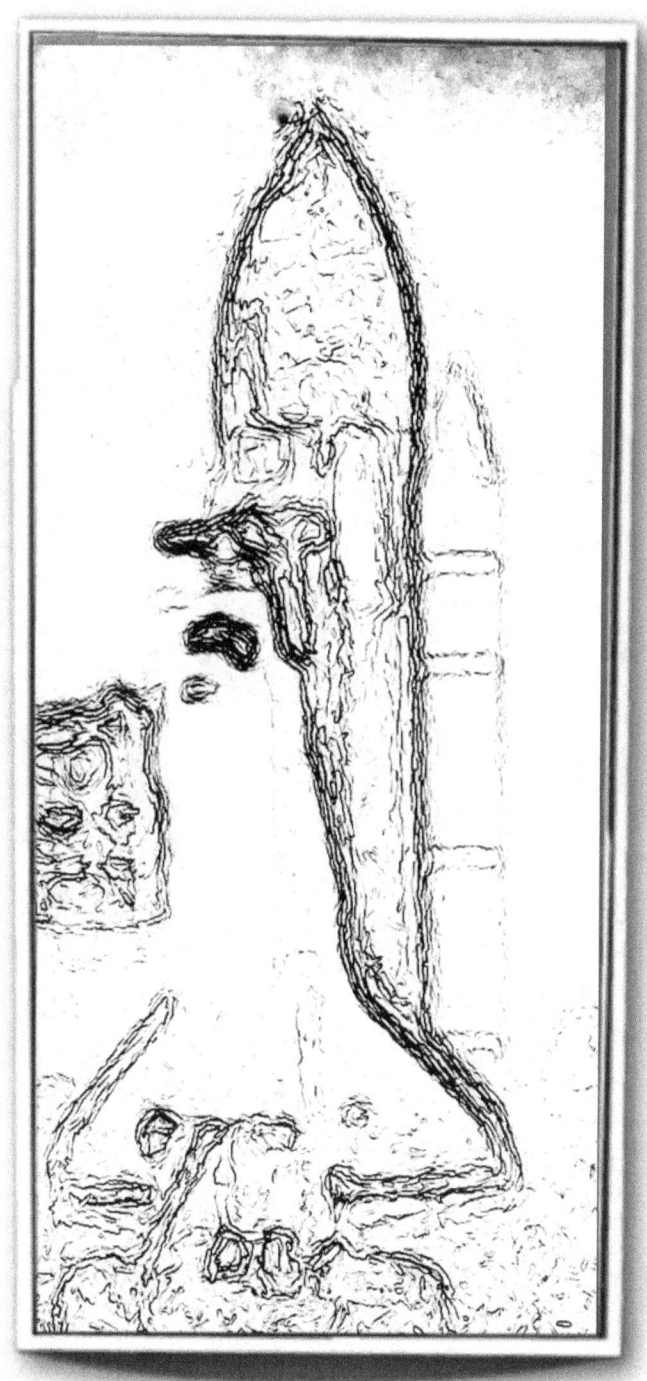

Hubble Space Craft. Tristan Riabo calls it, "Our eyes in Spaaaaaace"

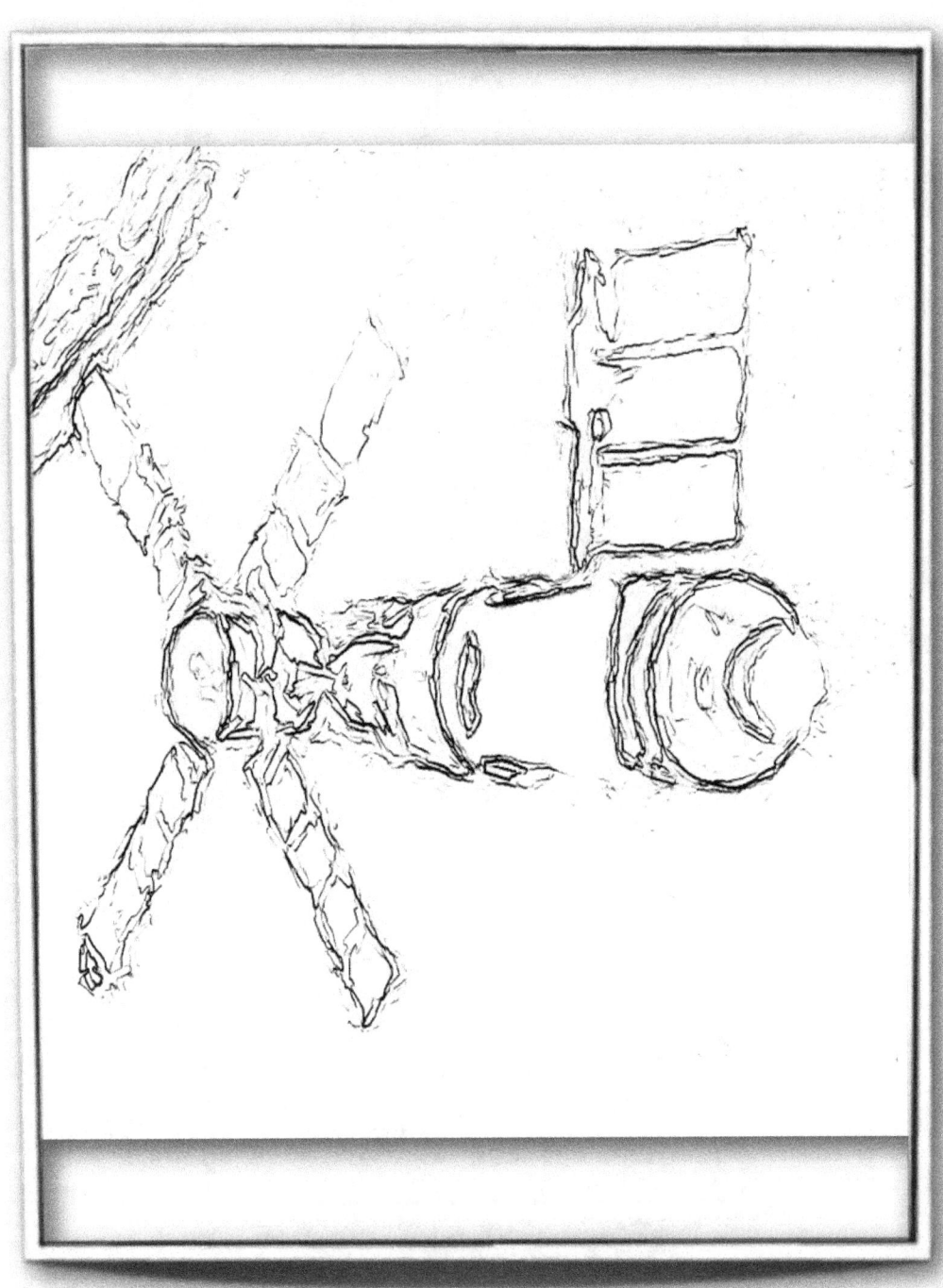

Hubble Space Craft from an artist (Tristan Riabo) view.

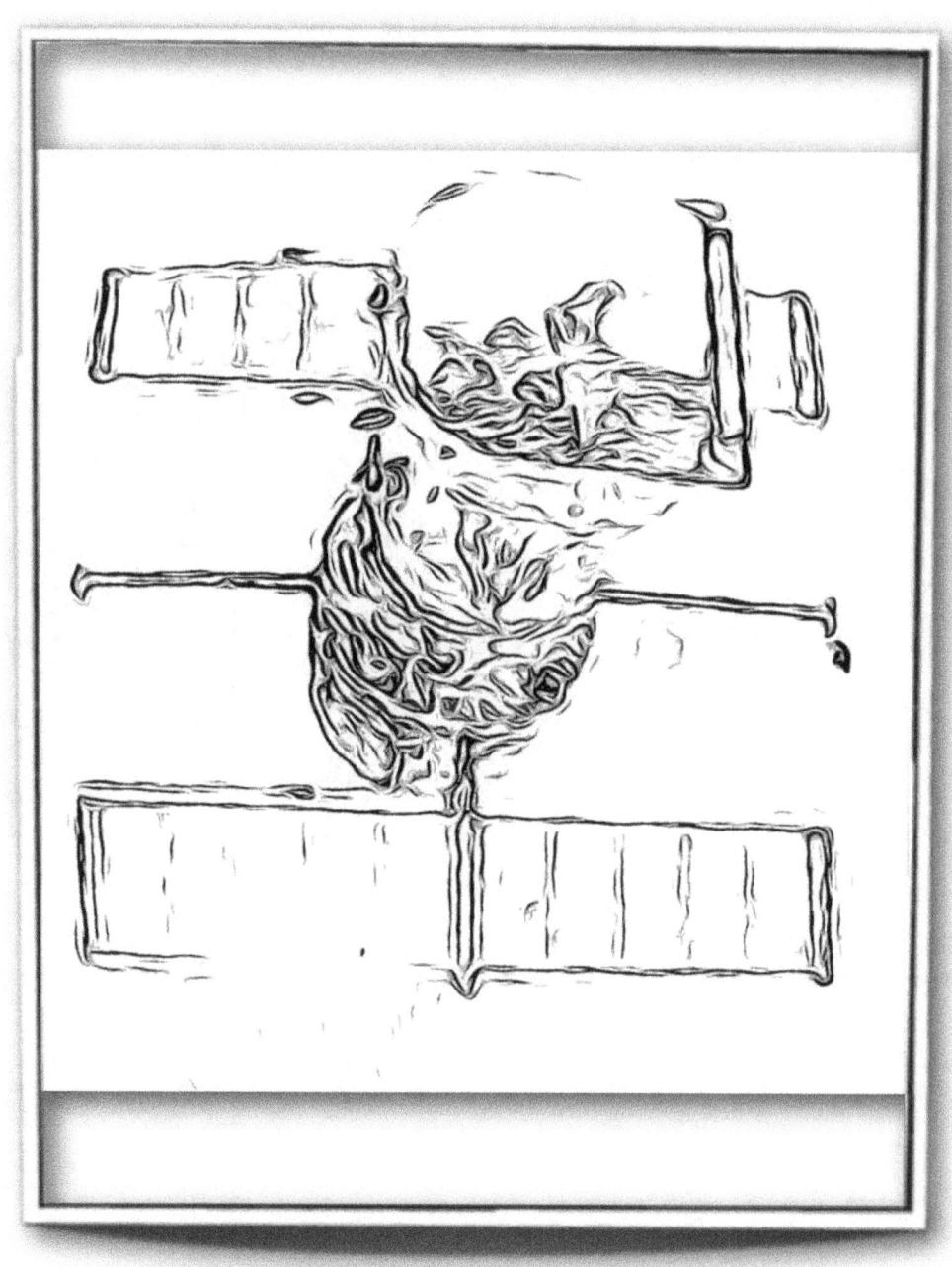

EARTH / MOON

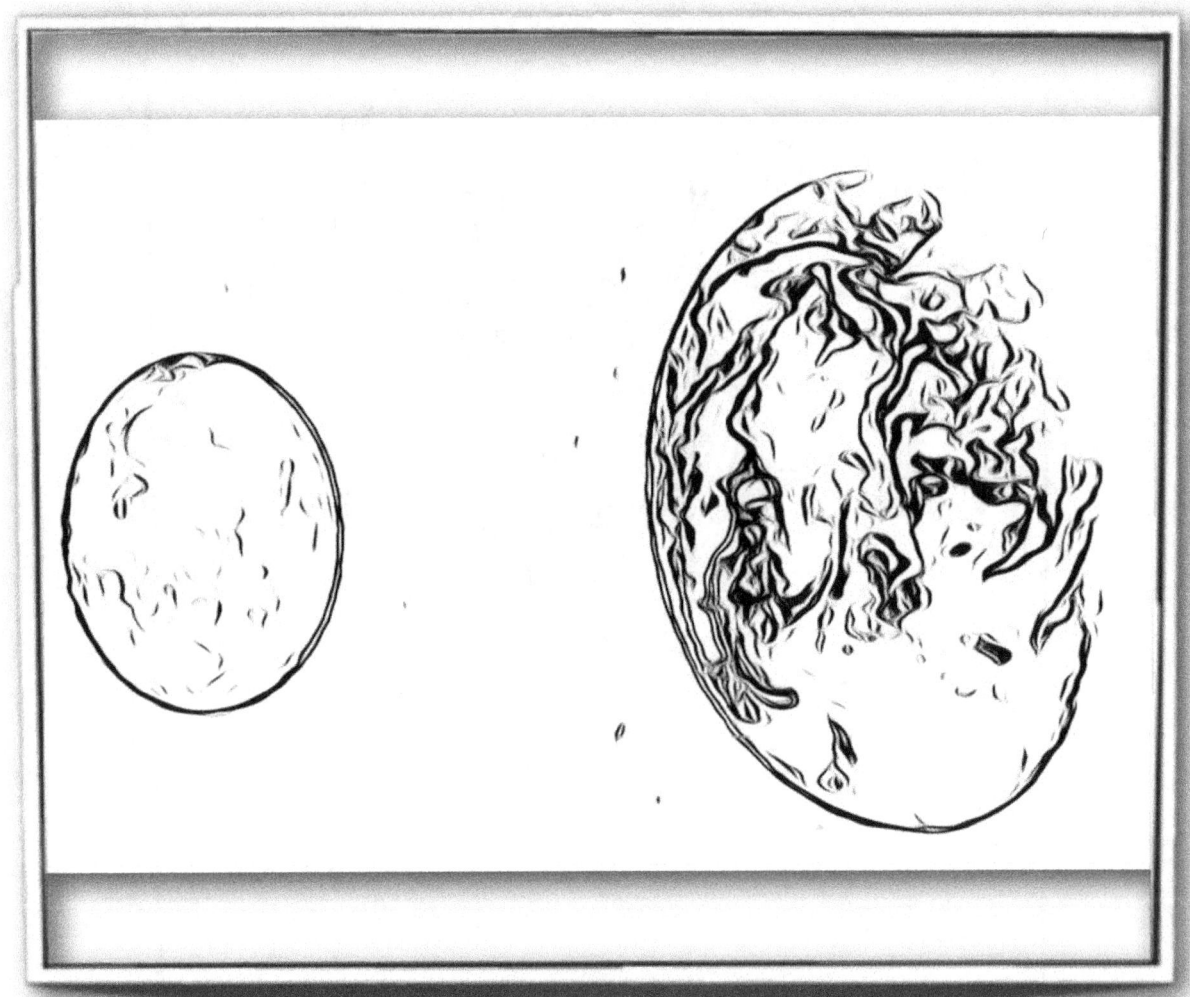

MAN ON THE MOON

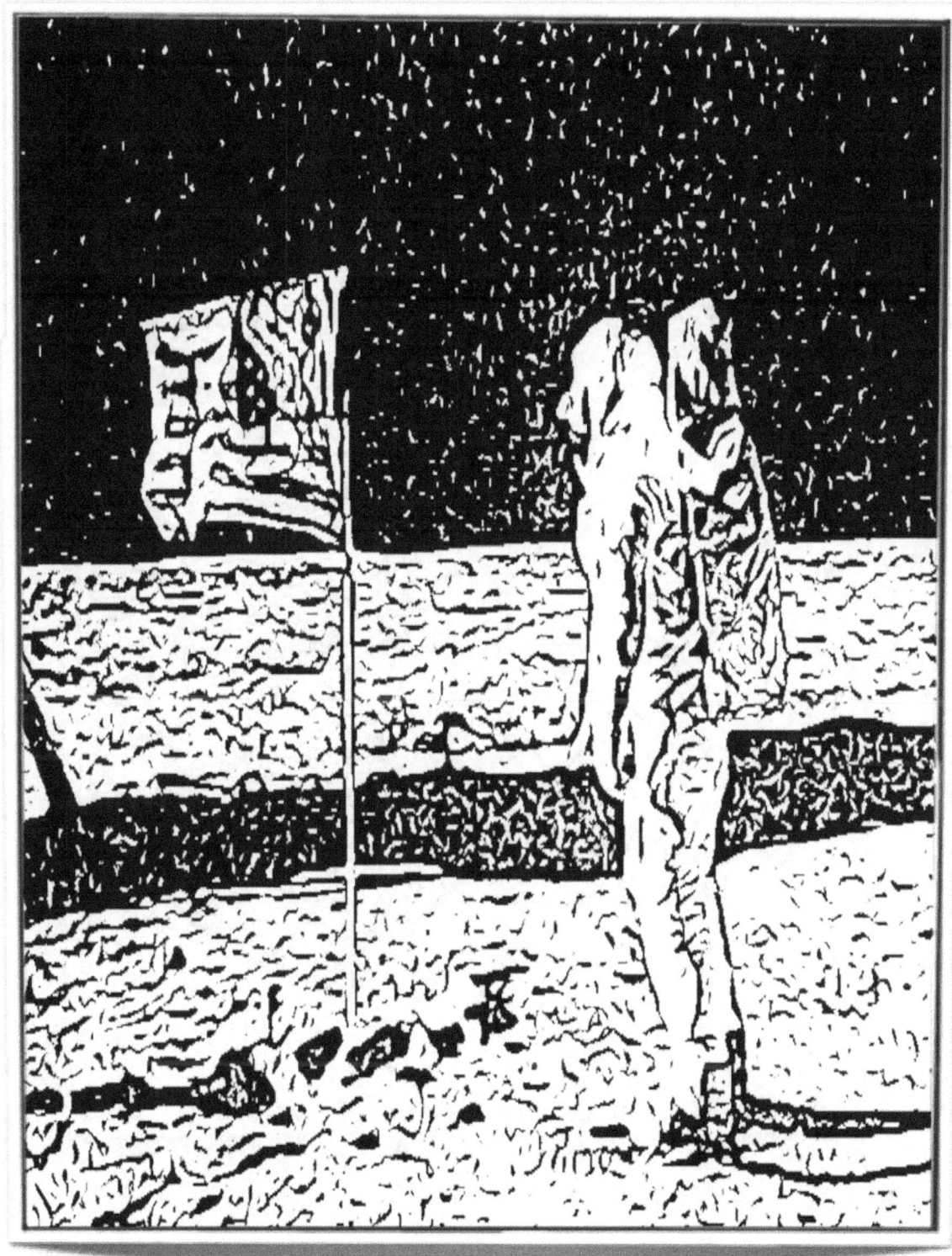

Welcome to Space Camp.

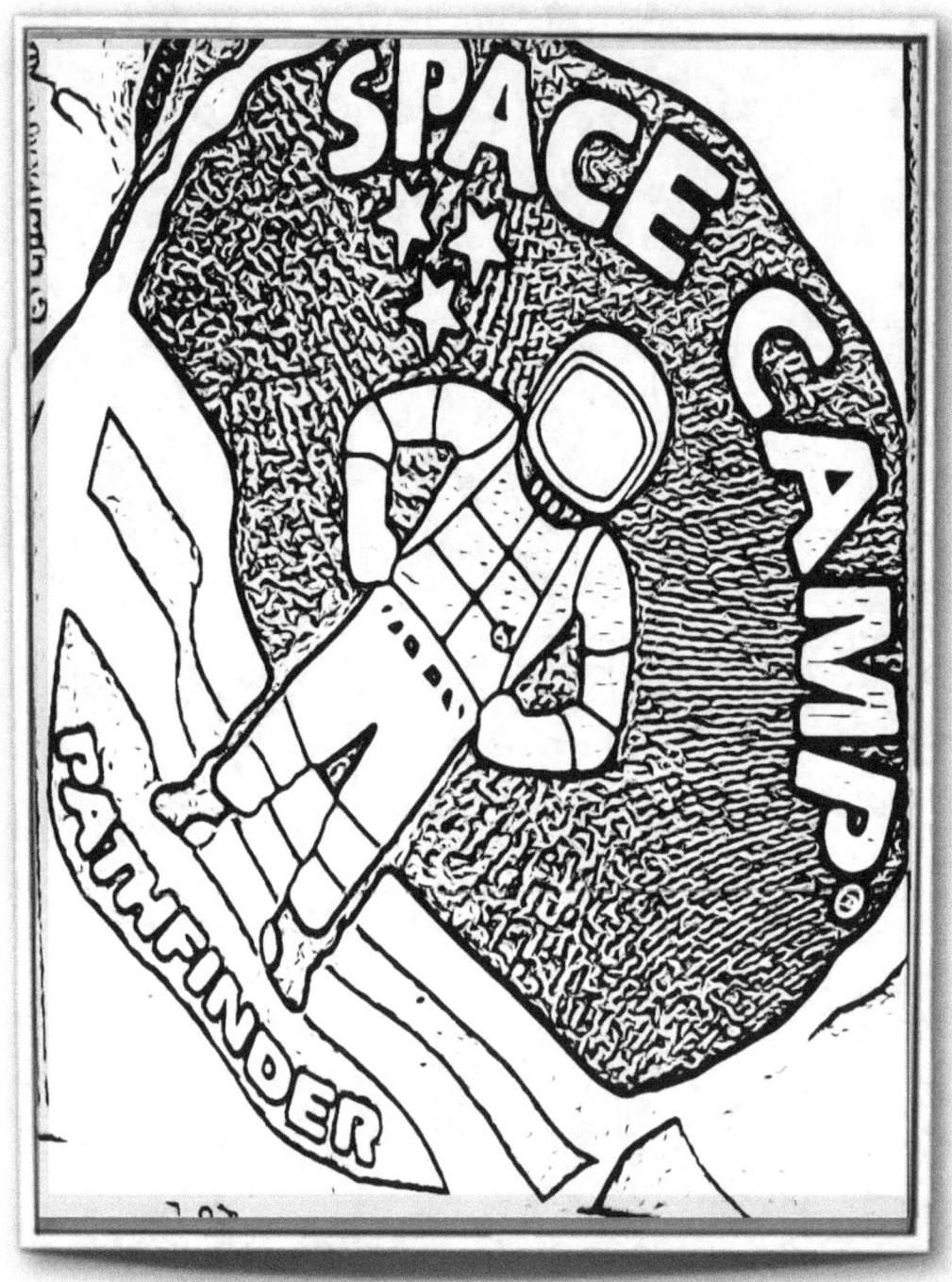

A sign at HUNTSVILLE INTERNATIONAL AIRPORT

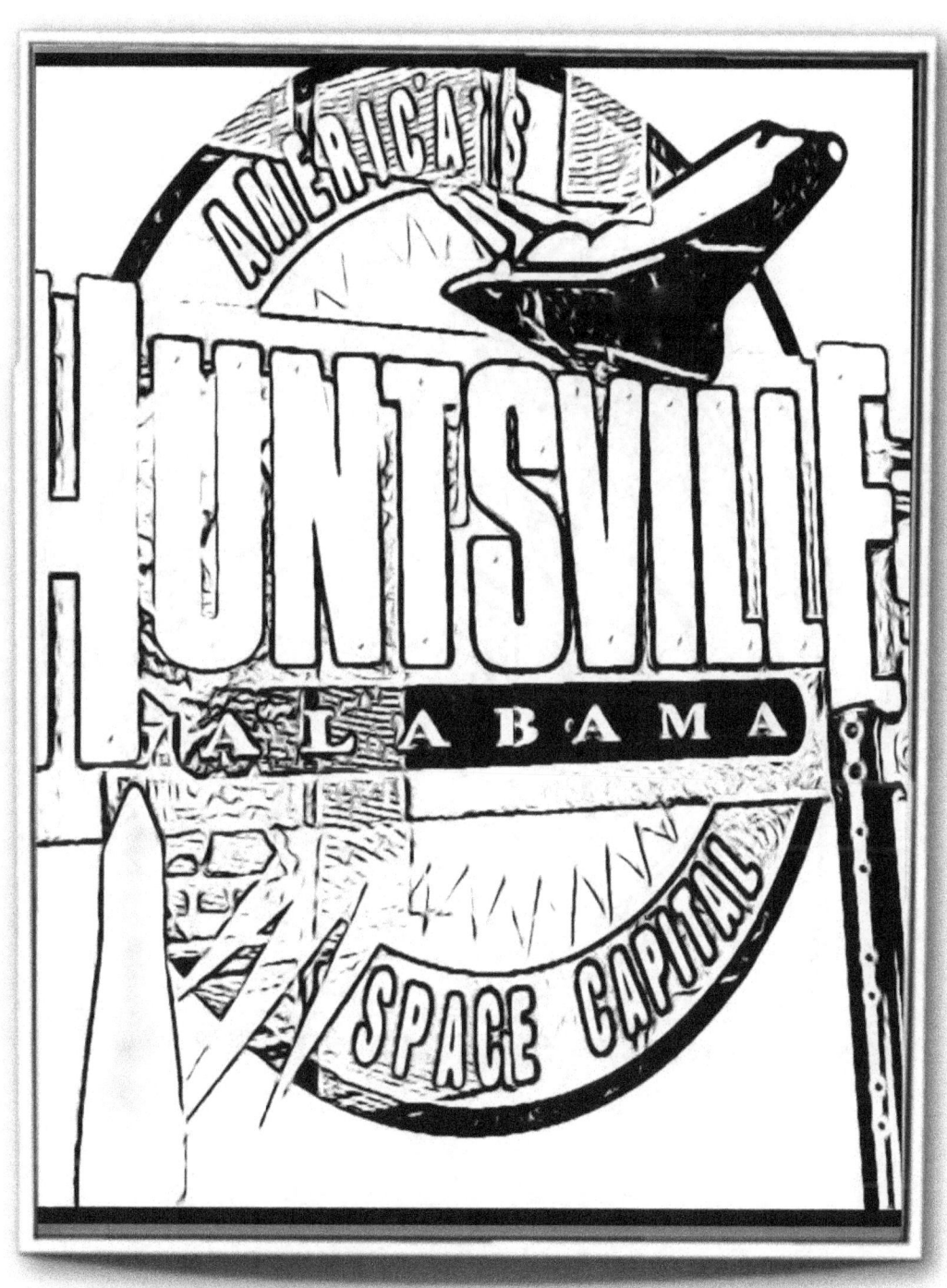

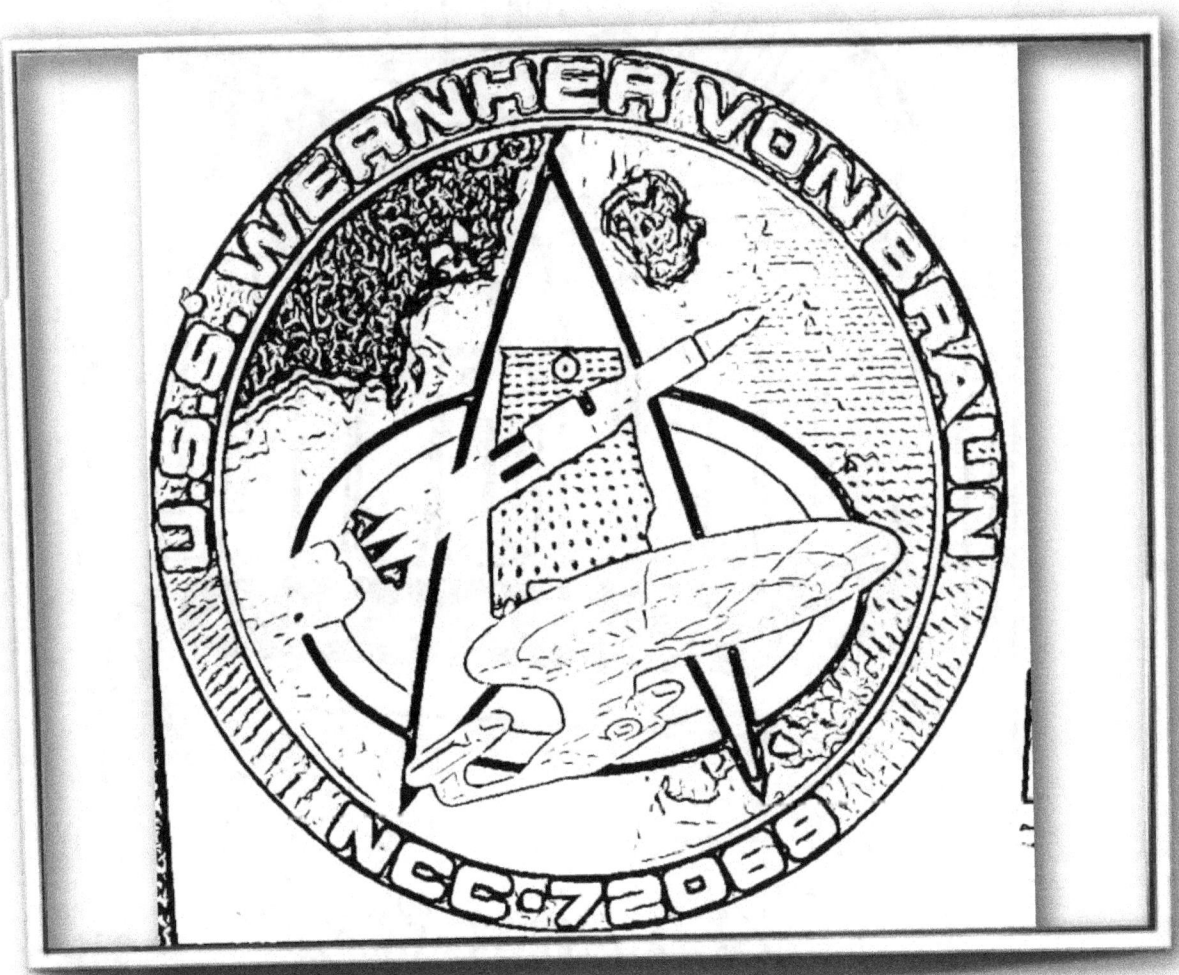

"Eggbeater Jesus" is not space-age but is uniquely Huntsville.
(BACK COVER uncolored)

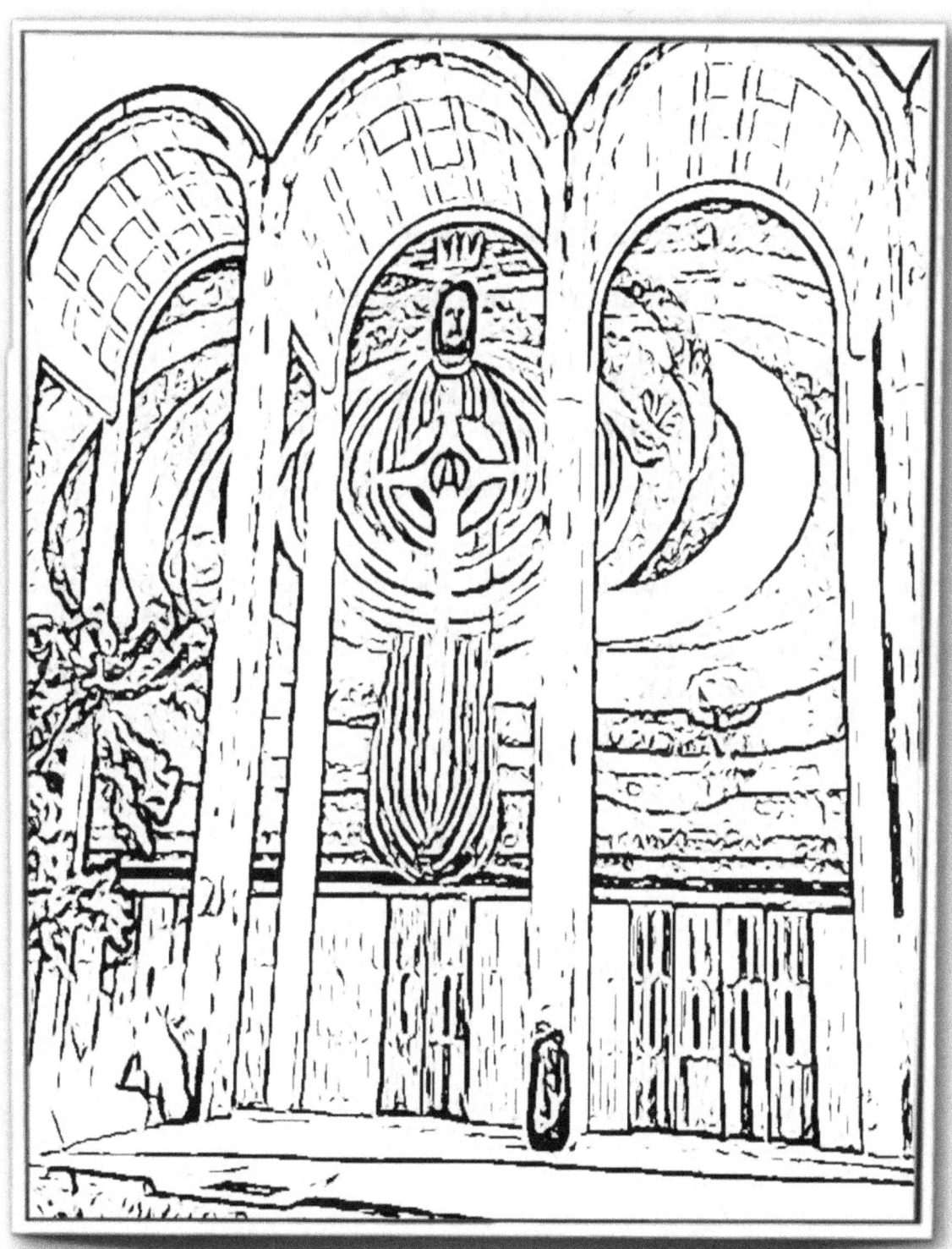

Thank you

Friends and family
Charles Ray, Bruce Guy, and Melanie Brockway Felker for helpful and gentle critiques.

=

Staff at Huntsville Public Library

Staff at Apple Store Bridge Street.

Look forward to coloring more fun books that show off the fun of The Rocket City.
Color Your Way Through The Rocket City:Hike
Color Your Way Through The Rocket City: Famous People
Color Your Way Through The Rocket City: Most Beautiful Images

SPECIAL REQUEST:
if I left out any image that you feel is a good idea for this topic please email me at www.tristan.riabo@gmail.com I would love tho hear your comments and suggestions. I may include them in a revised edition..

Thank you for buying this coloring book. I hope you enjoy coloring it.
May it entertain you and encourage you to learn more about STAR STUFF.

THANK YOU
Dr. Neil deGrasse Tyson for helping, "Star Stuff" become a mainstream term with your quote from the first episode of hit tv show COSMOS:.Standing Up In the Milky Way March 9, 2014.

"Stars die and reborn...
They get so hot that the nuclei of the atom fuse together deep within them to make the oxygen we breathe,
the carbon in our muscles,
the calcium in our bones,
the iron in our blood.
All was cooked in the fiery hearts of long vanished stars...
The cosmos os also within us.
We're made of star stuff.
We are a way for the cosmos to know itself."

U S Space and Rocket Center gave Dr. Tyson a model of the Saturn V.
The University of Alabama Huntsville awarded Dr. Tyson with and honorary doctoral degree..I am so thankful that people of science are celebrated.